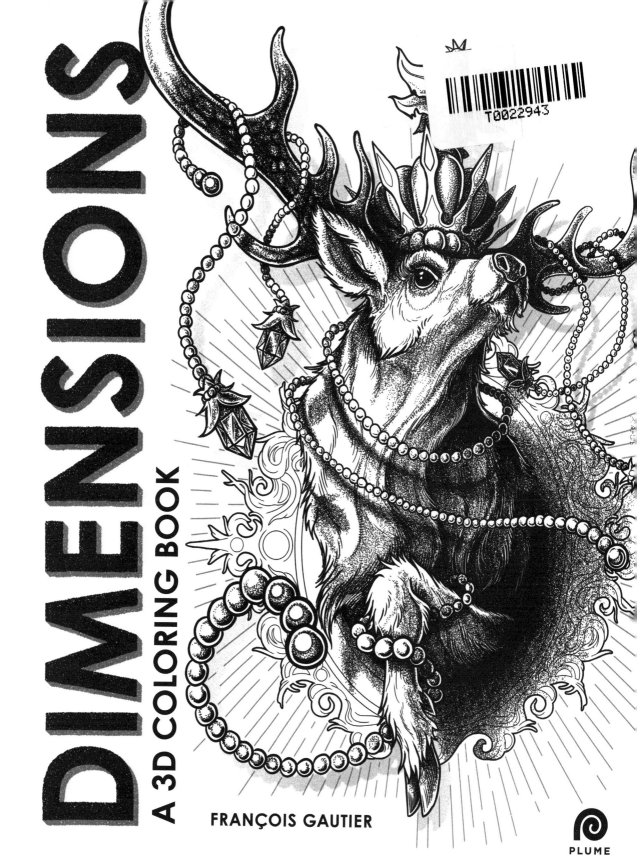

DIMENSIONS

A 3D COLORING BOOK

FRANÇOIS GAUTIER

PLUME

Illustrated by
François Gautier

Cover designed by John Bigwood
Edited by Susannah Bailey
Designed by Jade Moore

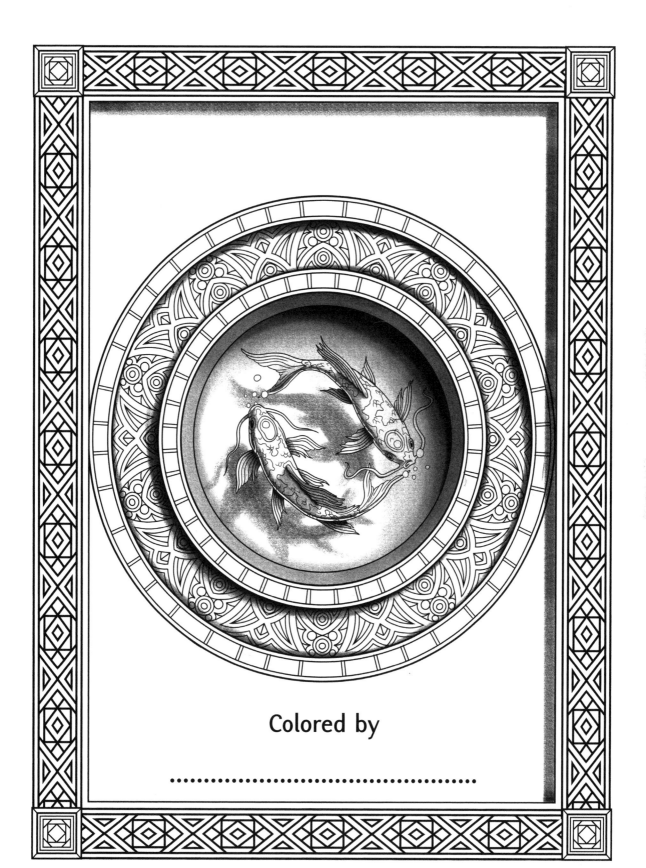

Colored by

......................................

PLUME

An imprint of Penguin Random House LLC

penguinrandomhouse.com

W www.mombooks.com/lom

MichaelOMaraBooks

OmaraBooks

lomartbooks

ISBN 9780593187135

Printed in the United States of America
1 3 5 7 9 10 8 6 4 2

Introduction

This is a coloring book all about three dimensions,
with pictures leaping out of the pages.

The 3D effect is created through shading, and the contrast
between the lighter and darker areas. When coloring the
pictures, it's useful to work out where the light source is,
as that will determine where the shadows fall. This will help
you decide how much shading to add and where to place it.
The parts of your pictures that are projected forward and caught
by the light will be brighter and need no shading, whereas those
recessed in the dark will require more shadows. You can follow
the shadows that have already been added as a guide, but feel
free to color over shading to create your own effects.

However you choose to approach it, we hope you
enjoy bringing the world of *Dimensions* to life.

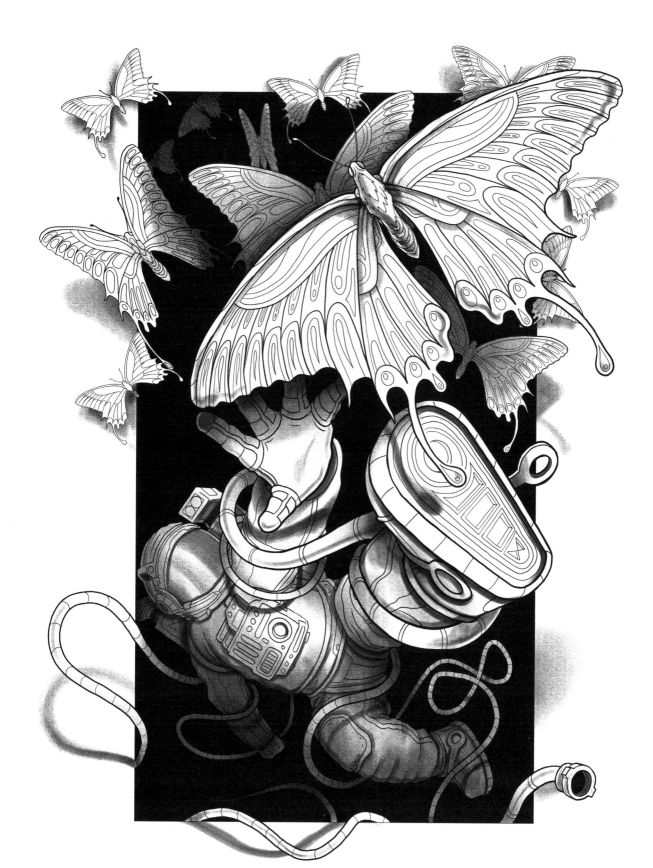

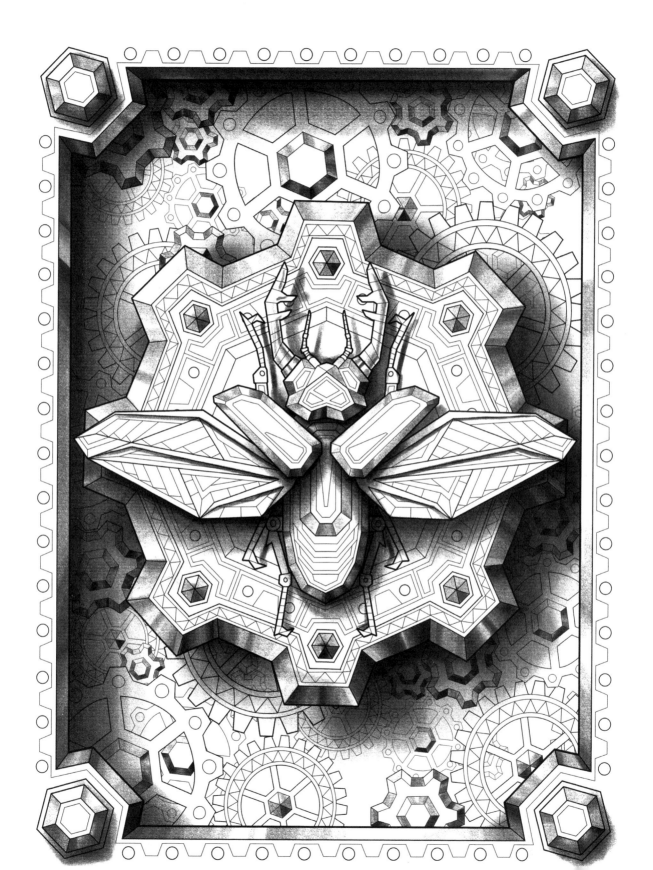

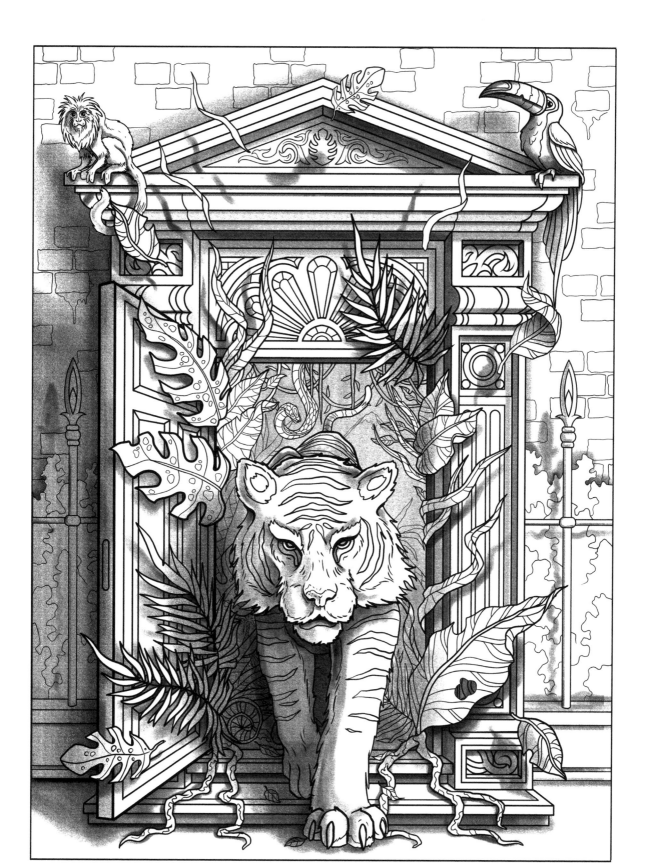

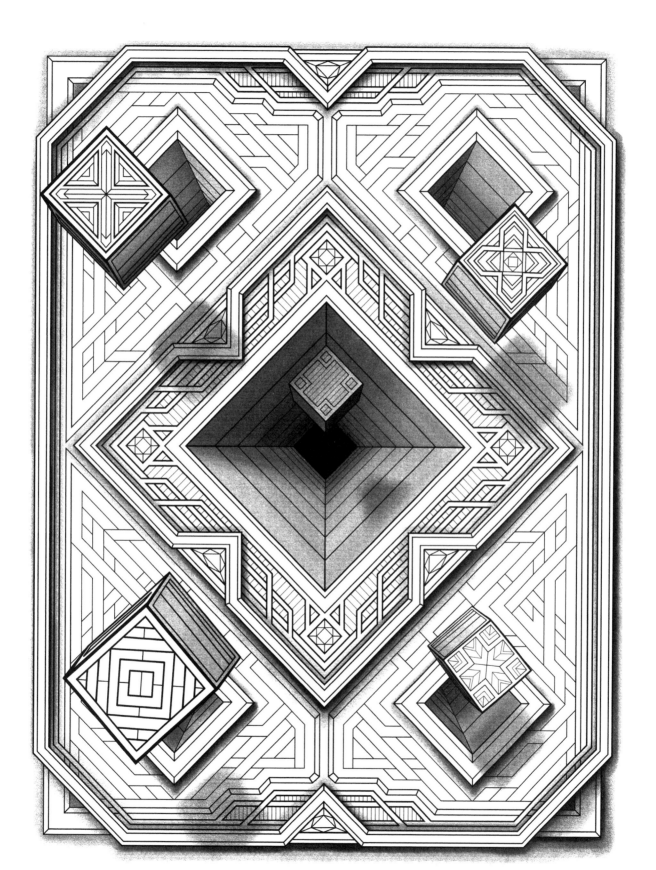

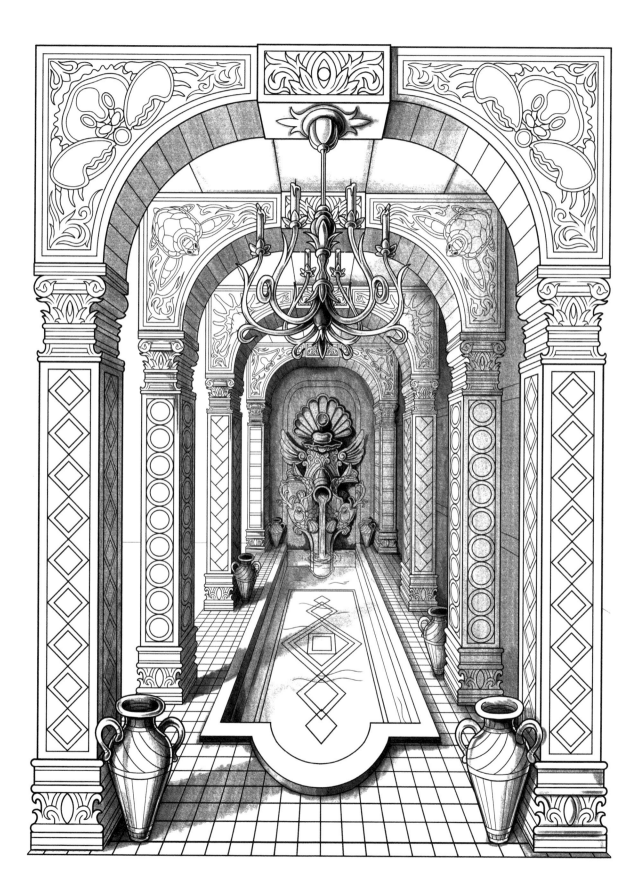

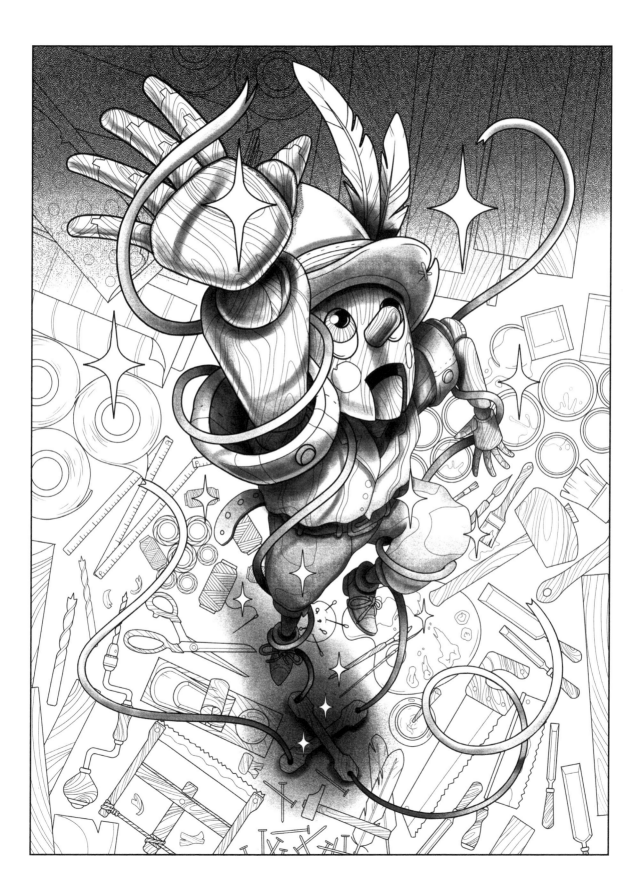

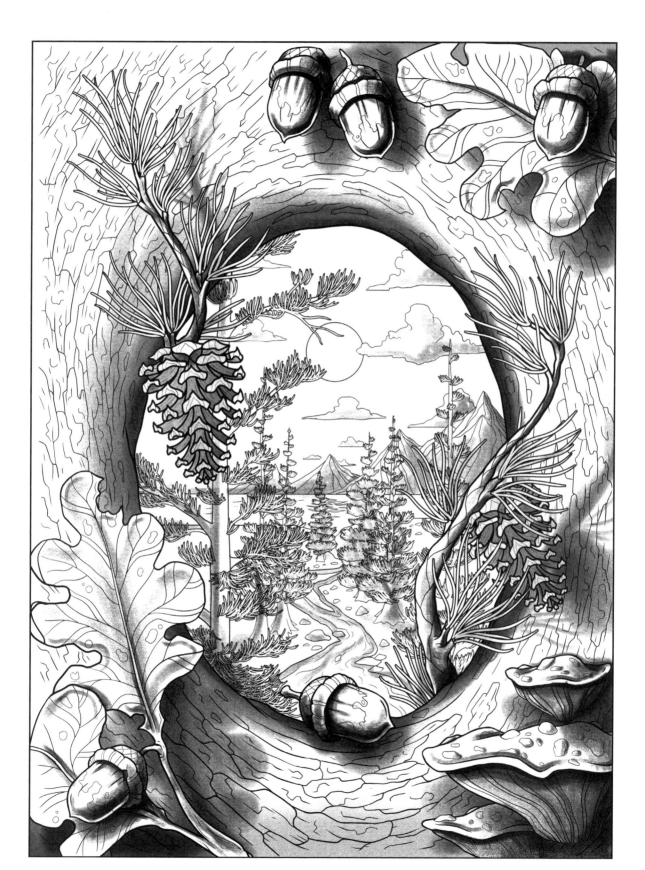

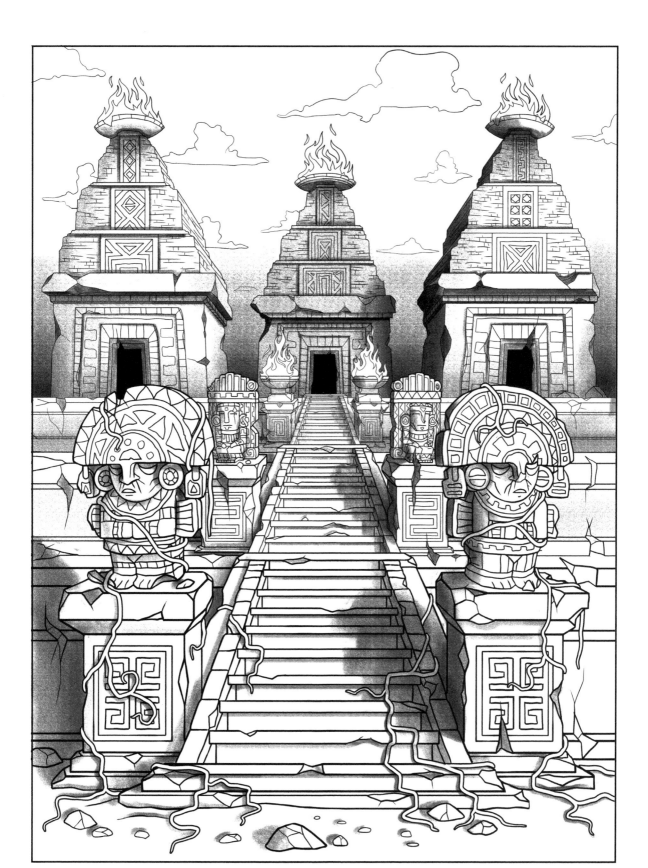

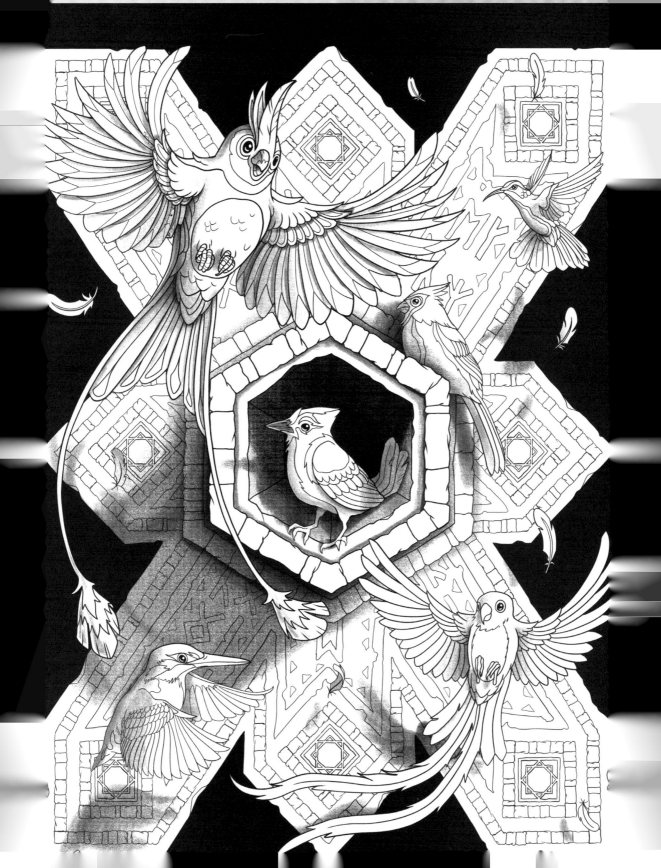

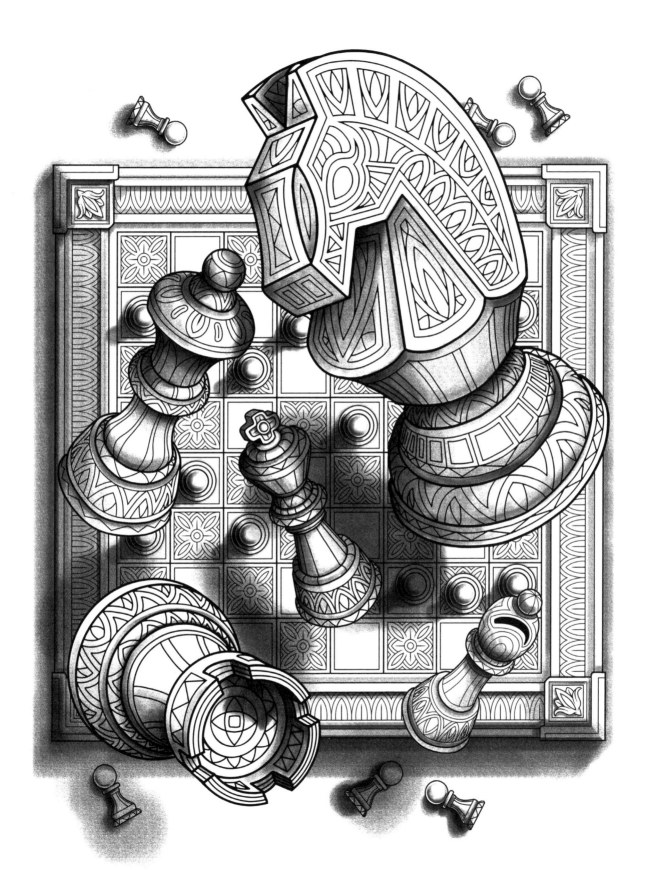

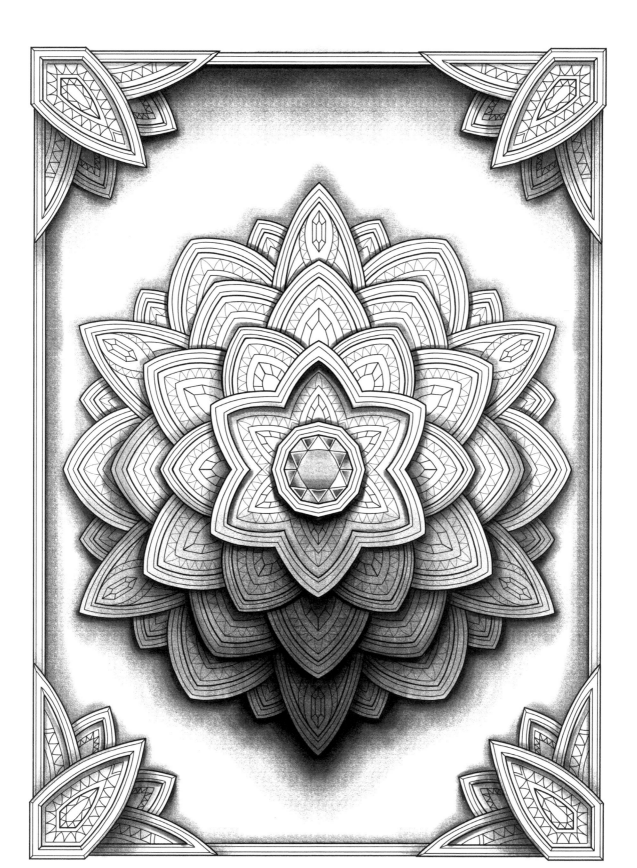

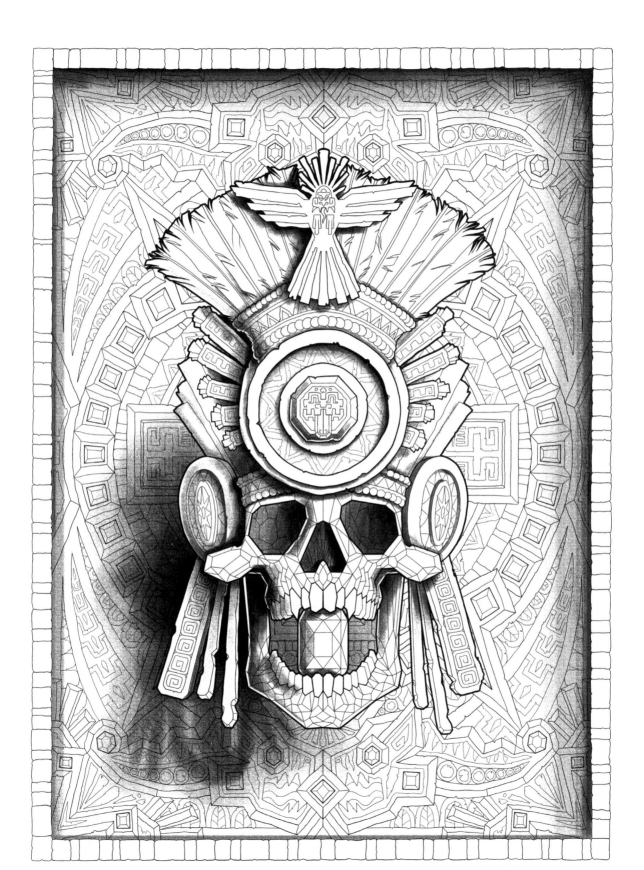

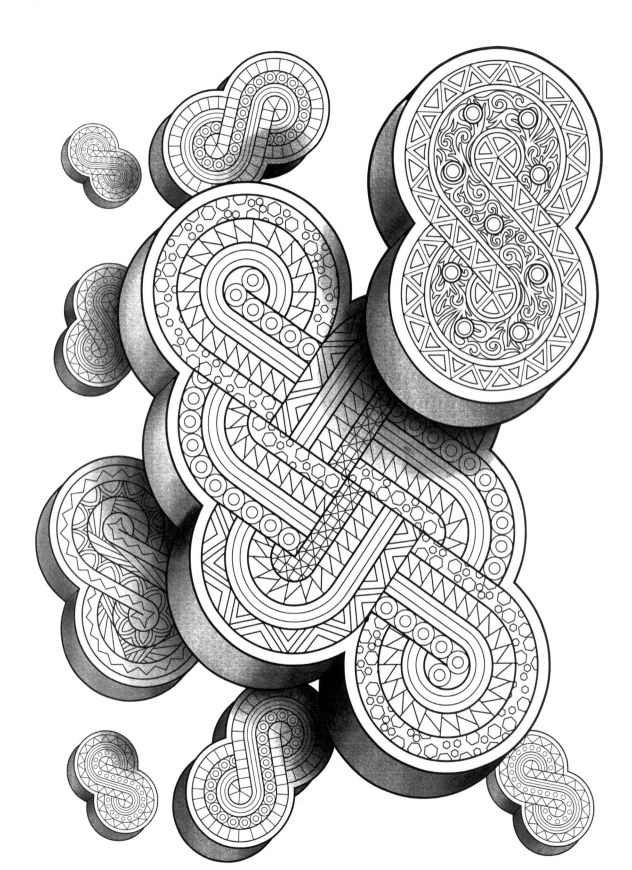

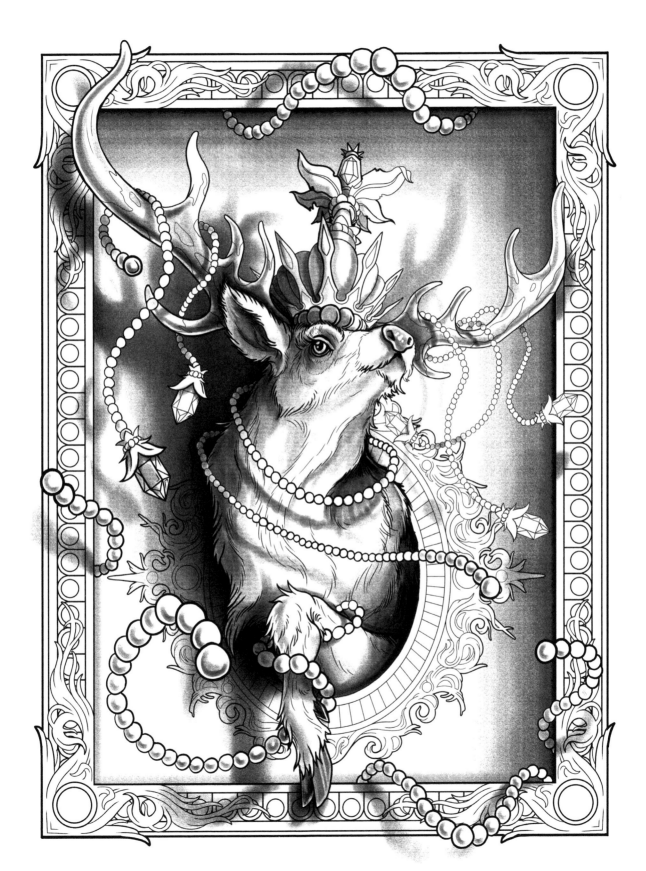

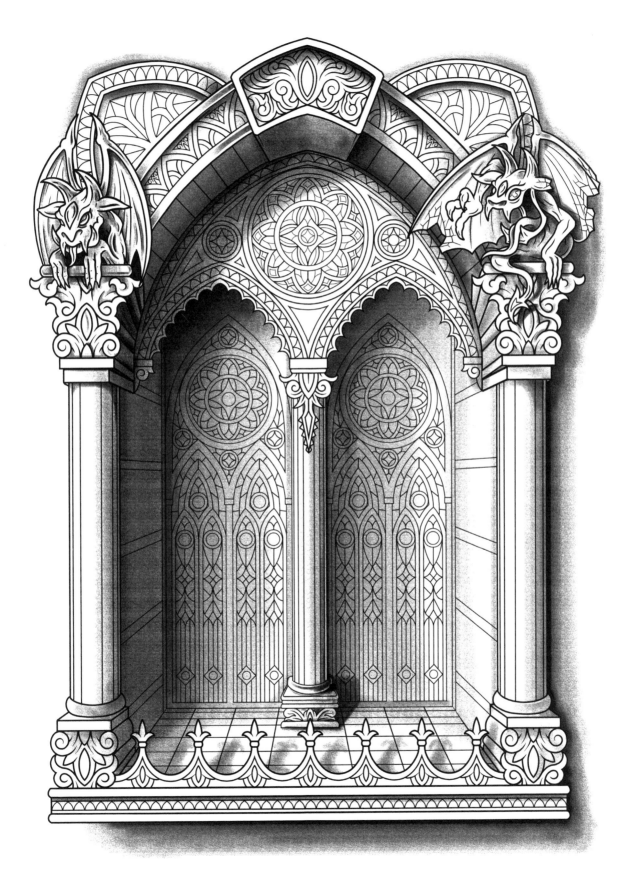

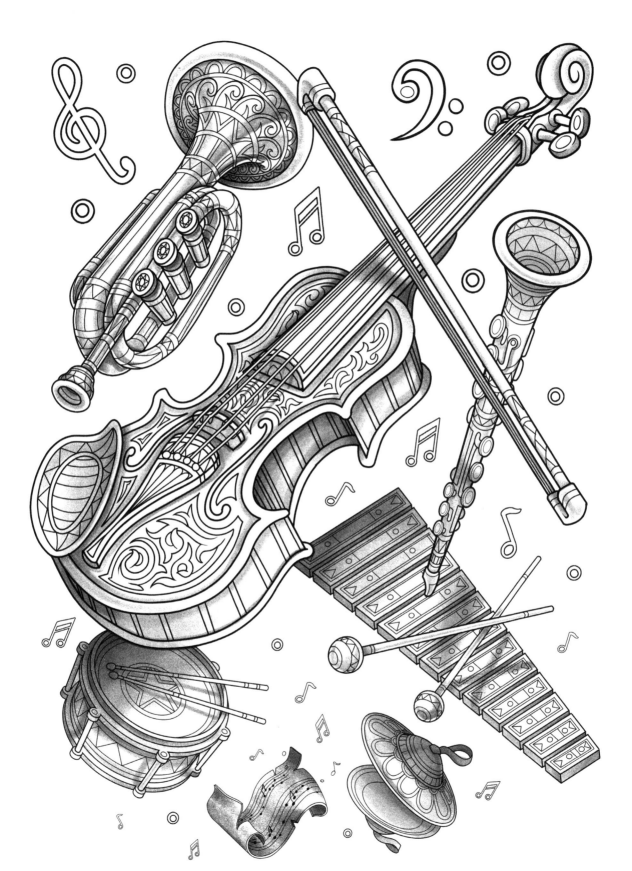

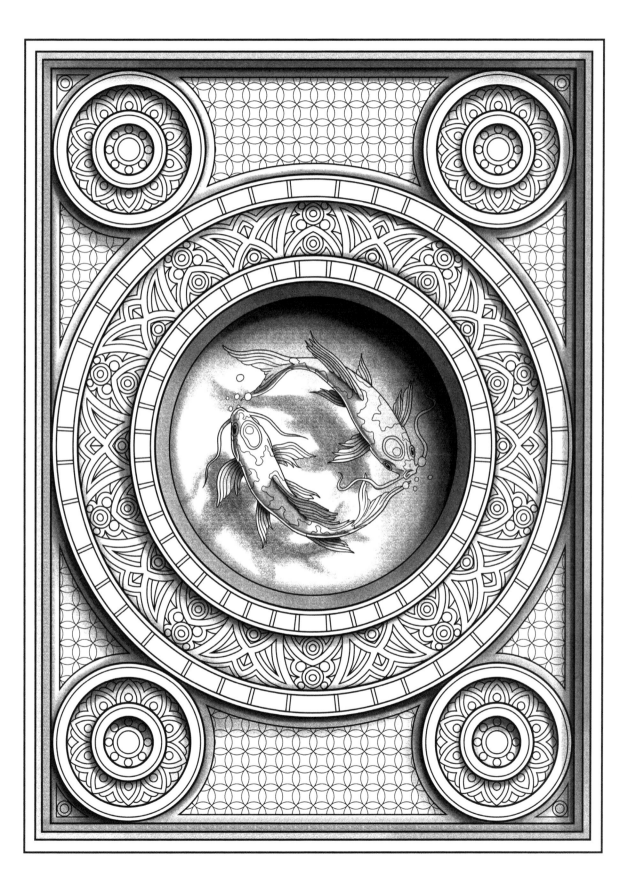

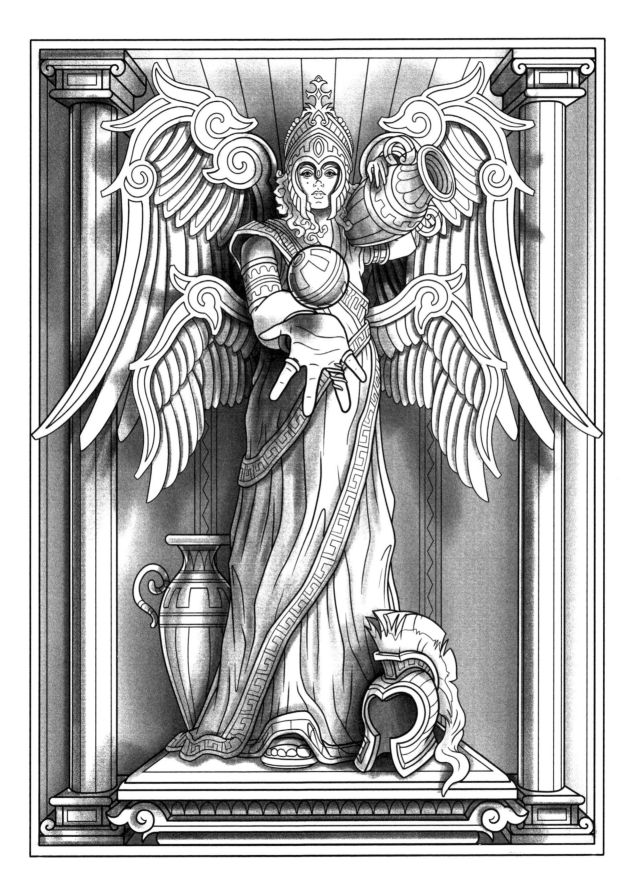

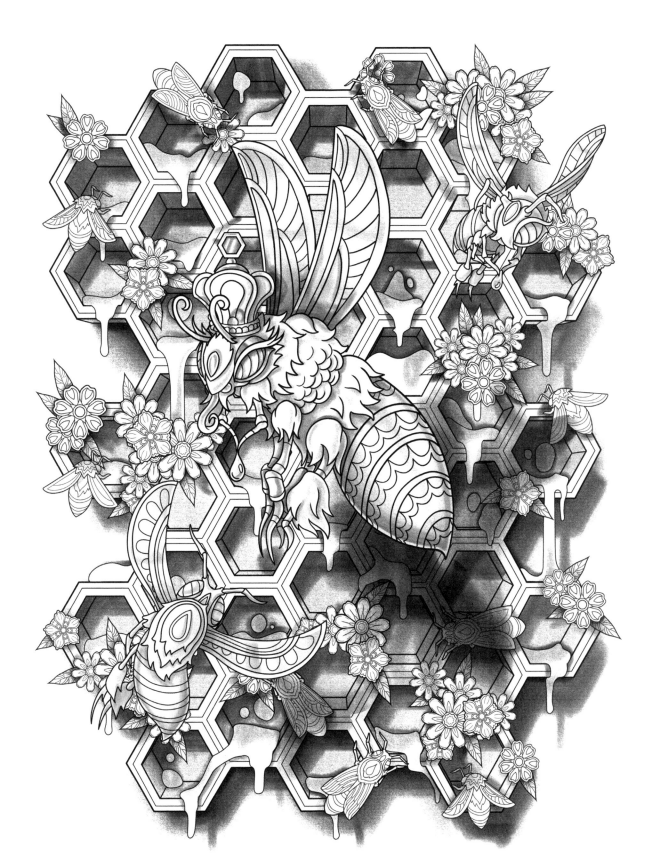

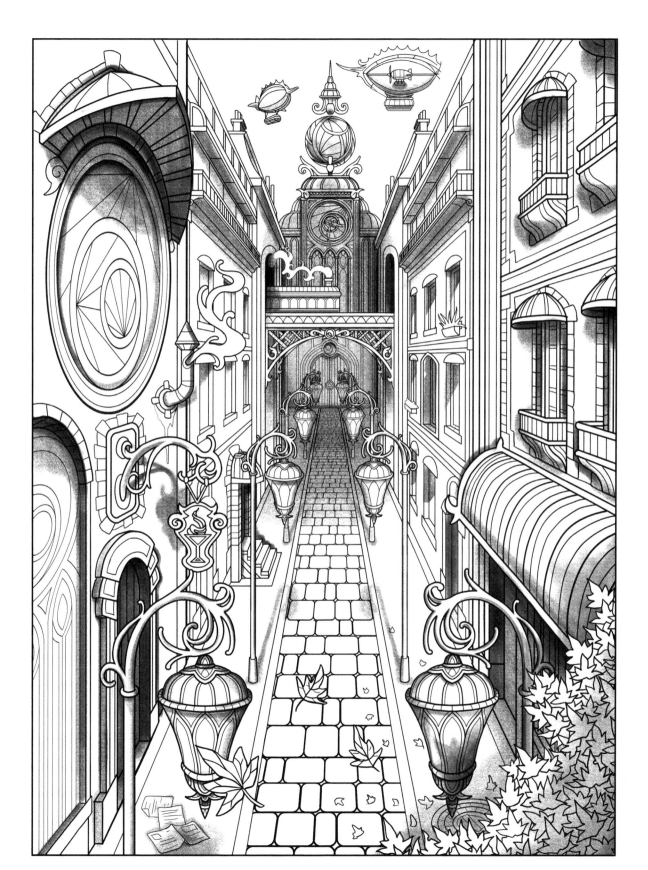

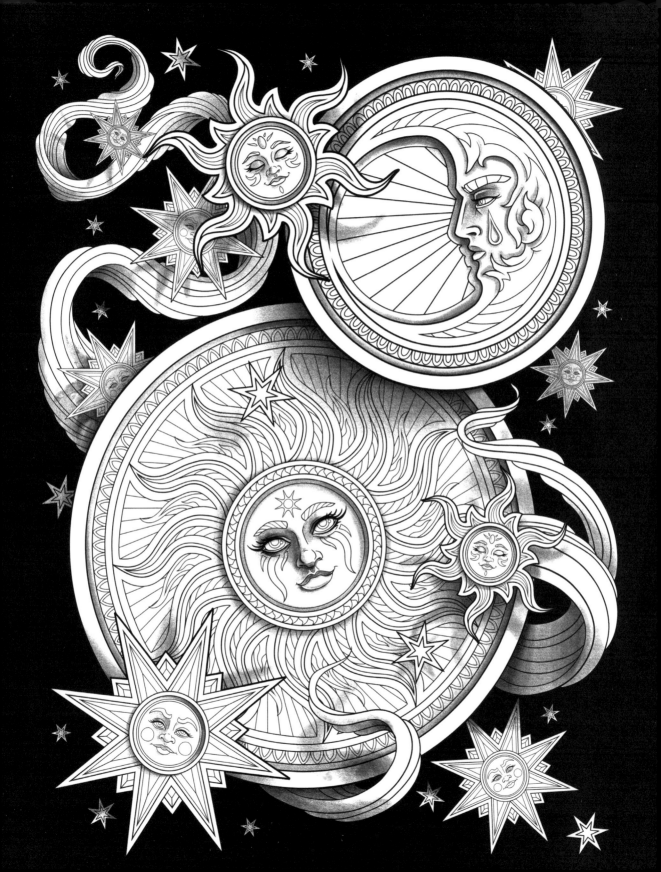

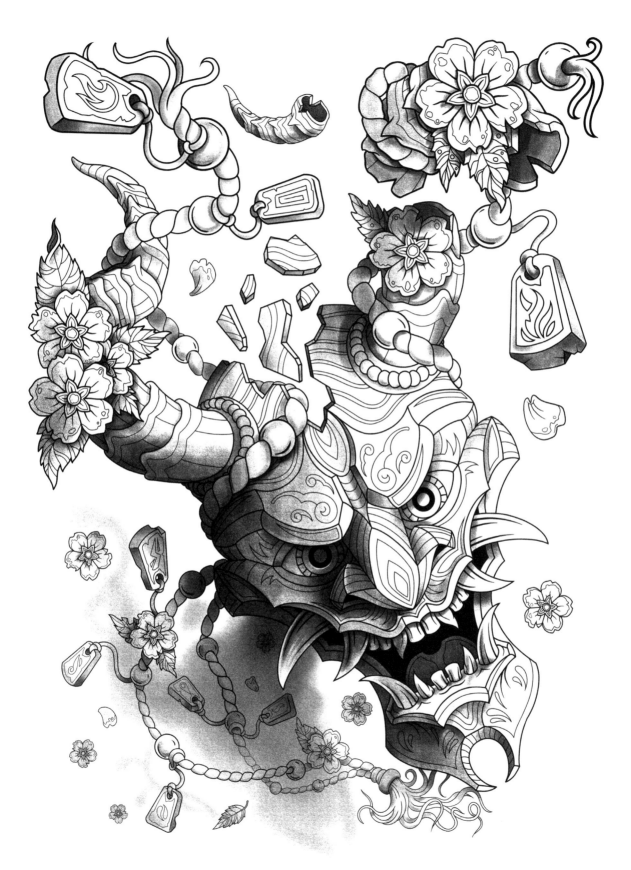

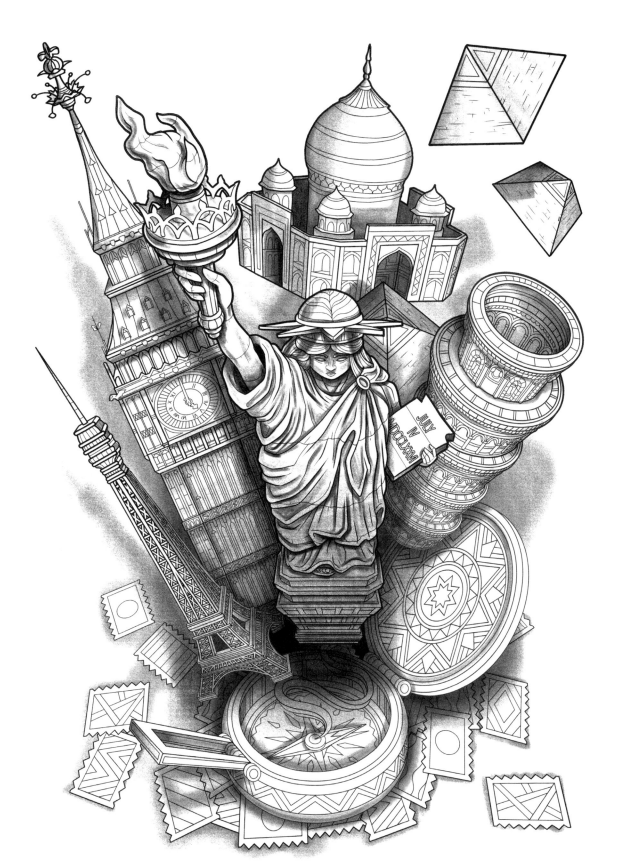

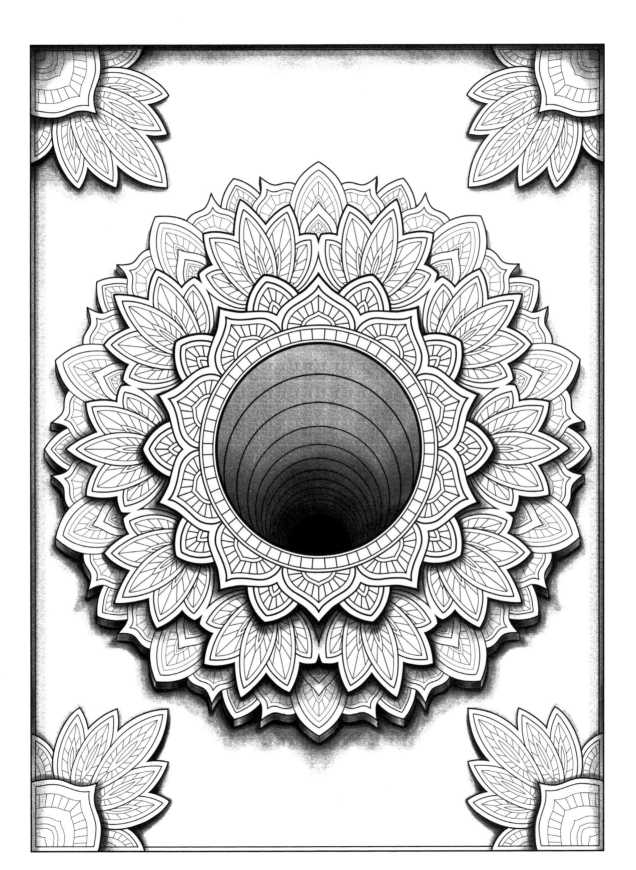

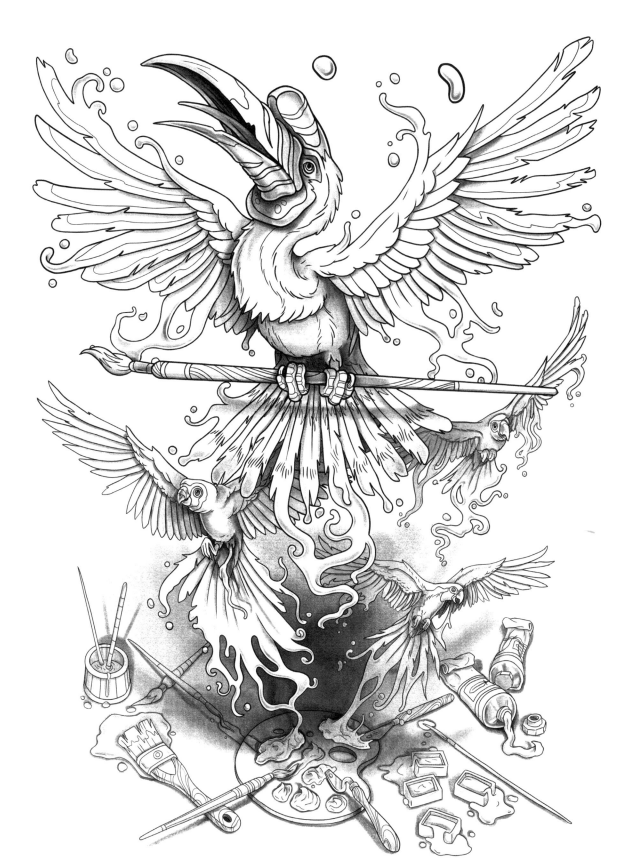

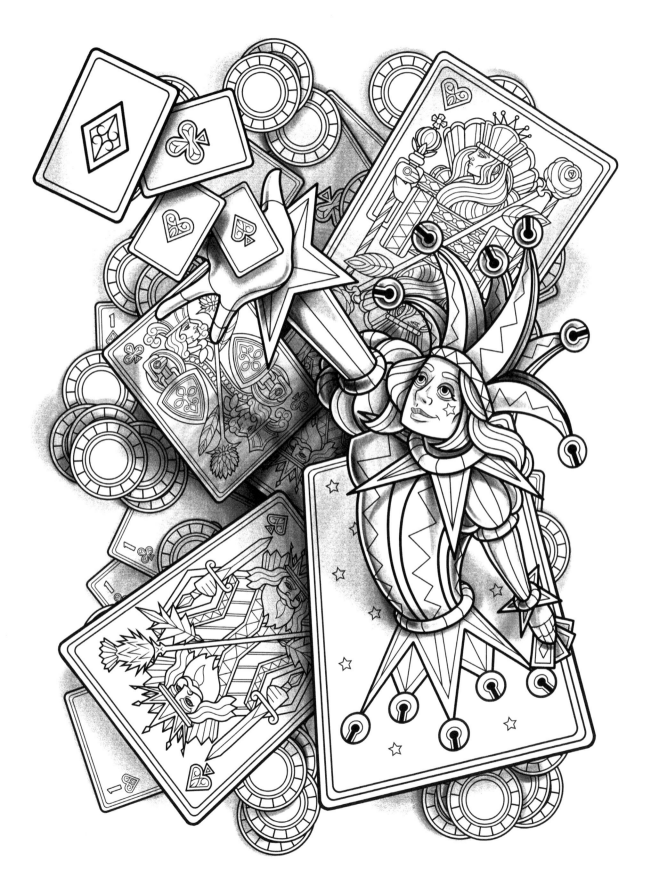

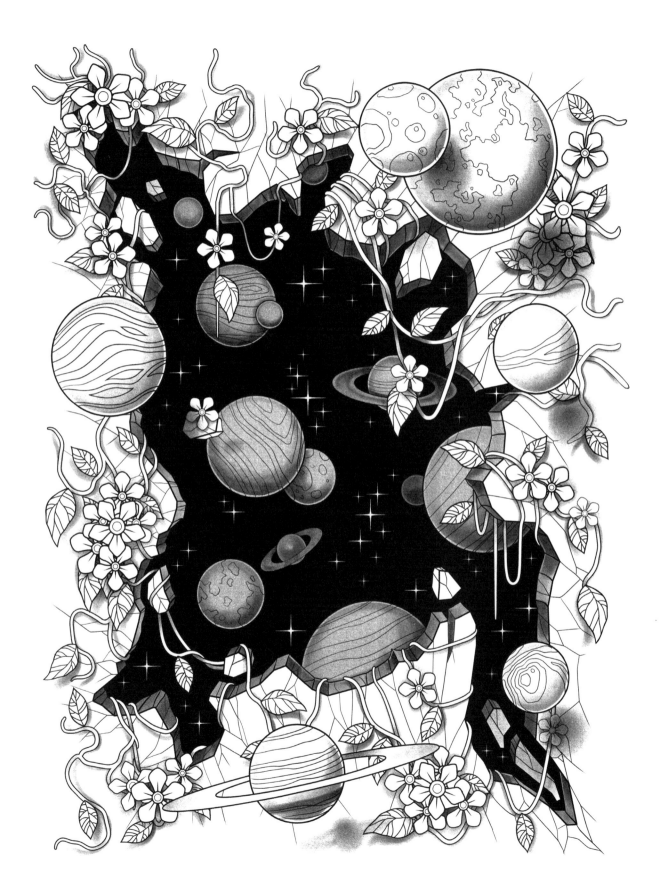

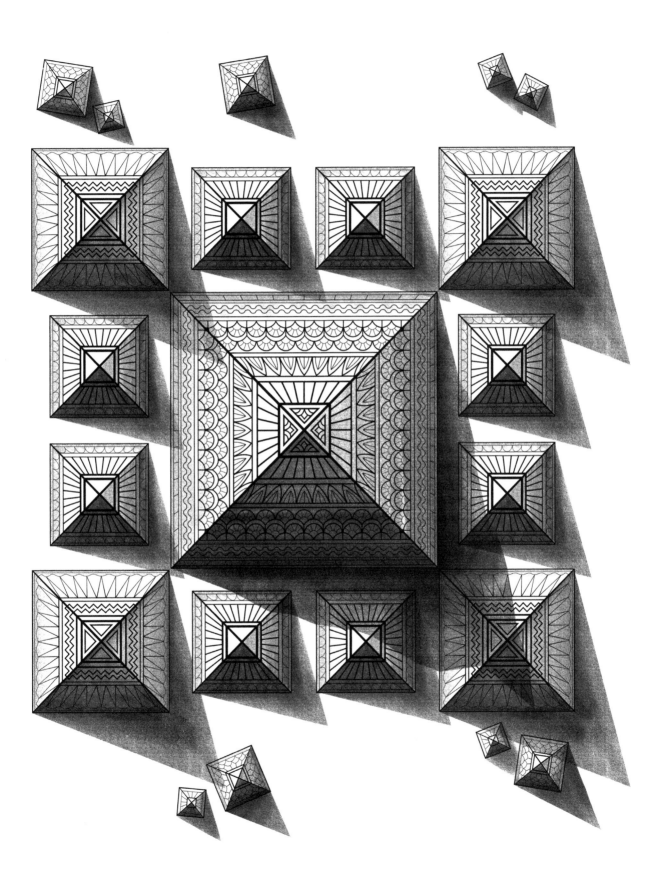

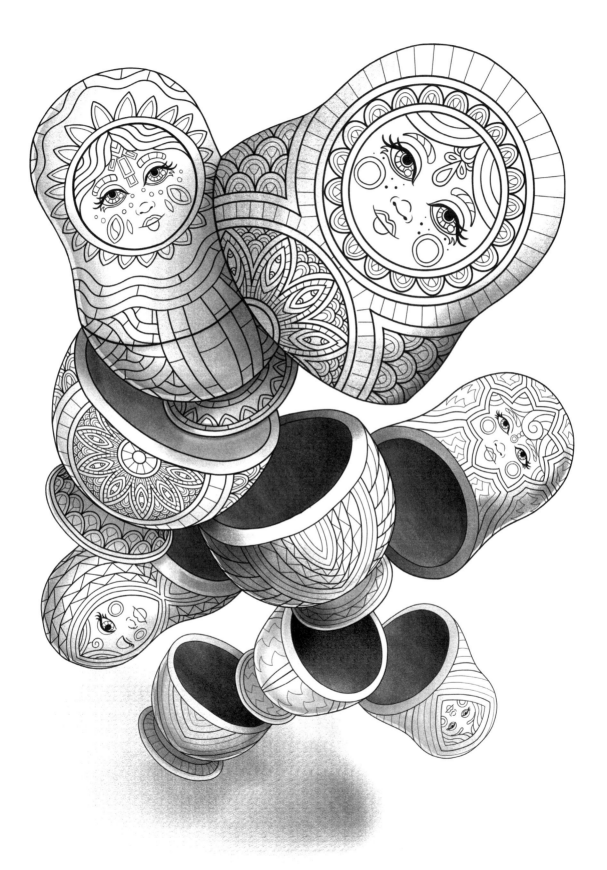

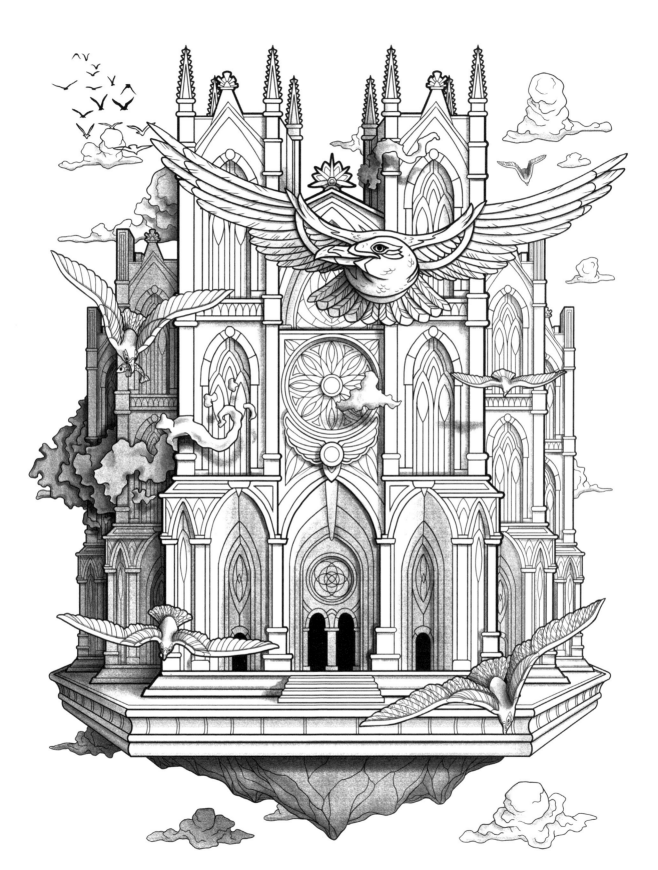

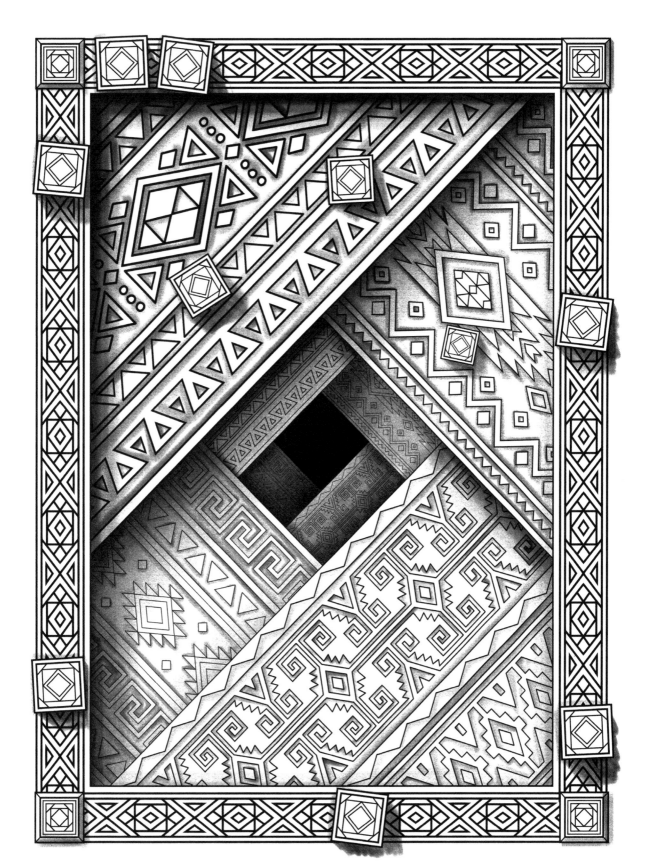

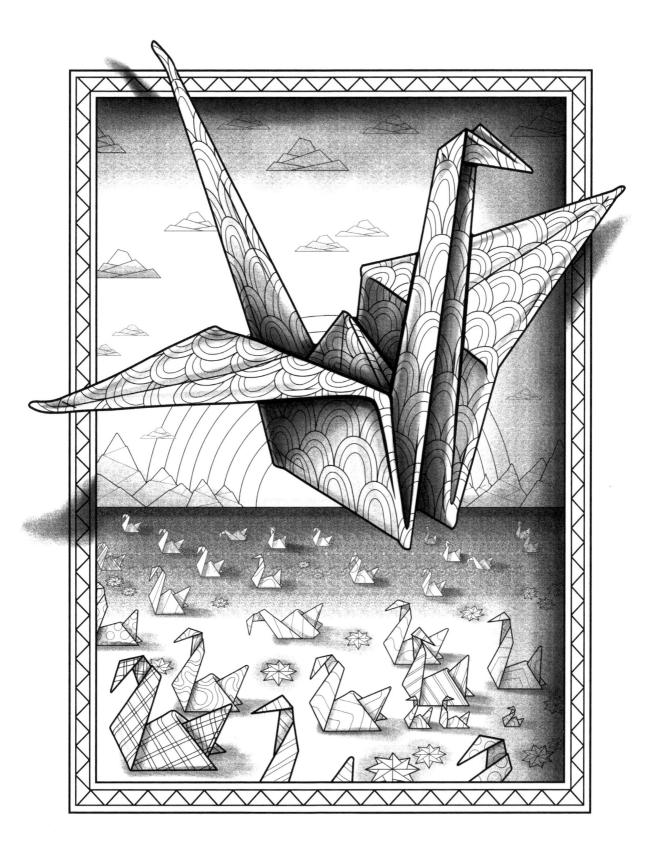

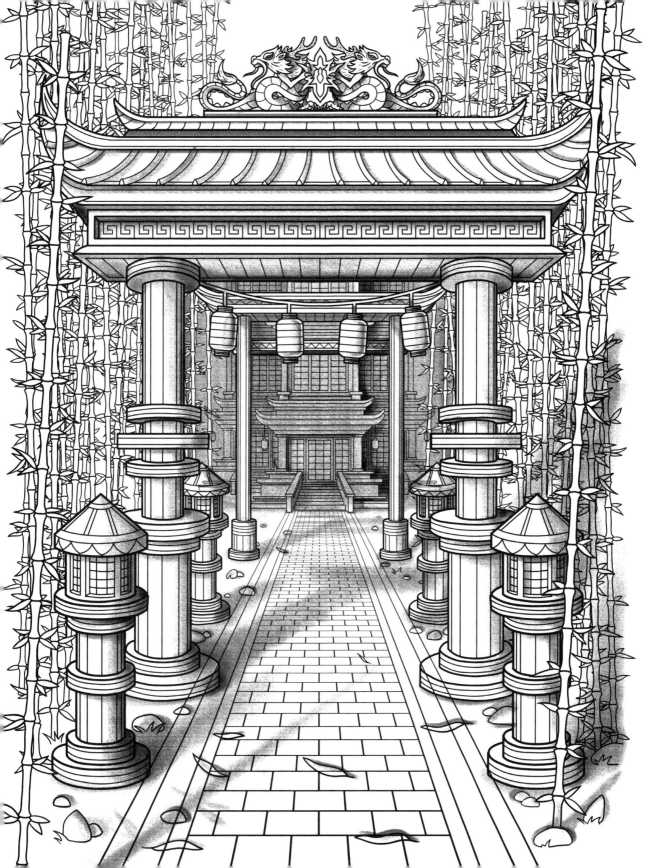

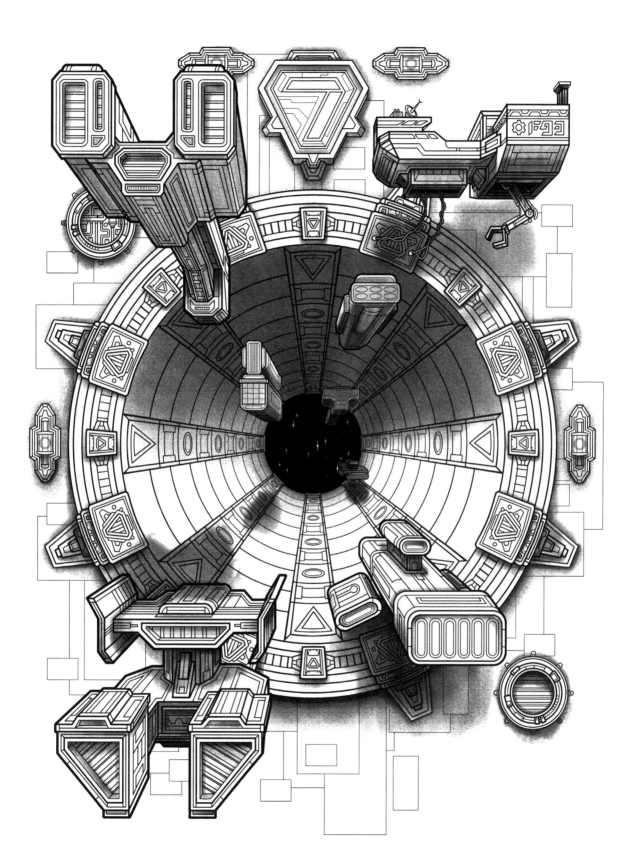

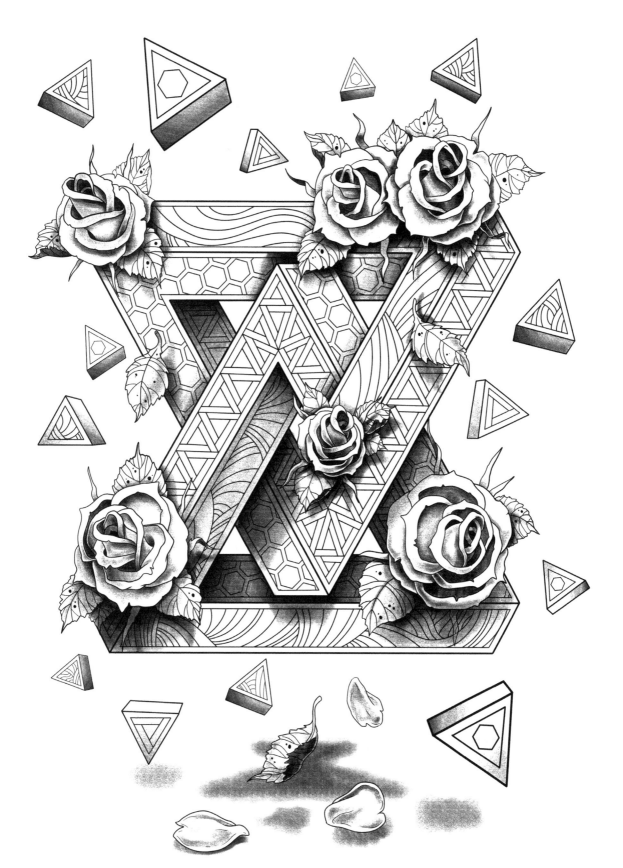

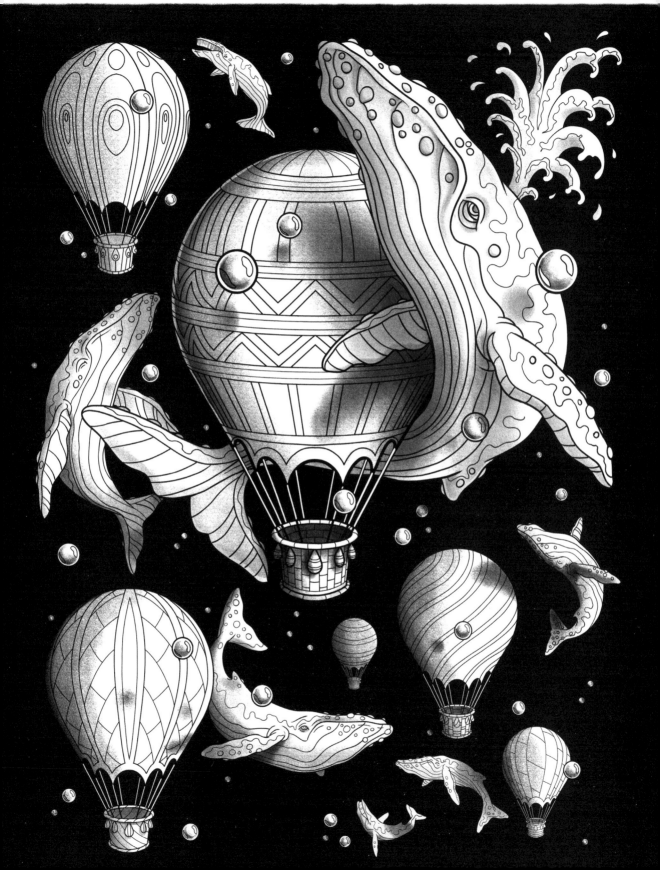

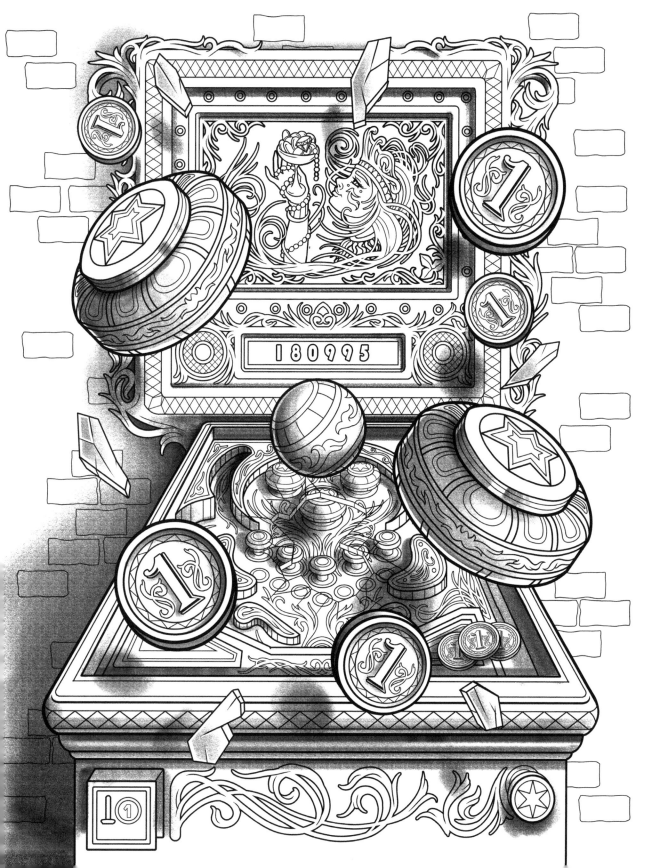

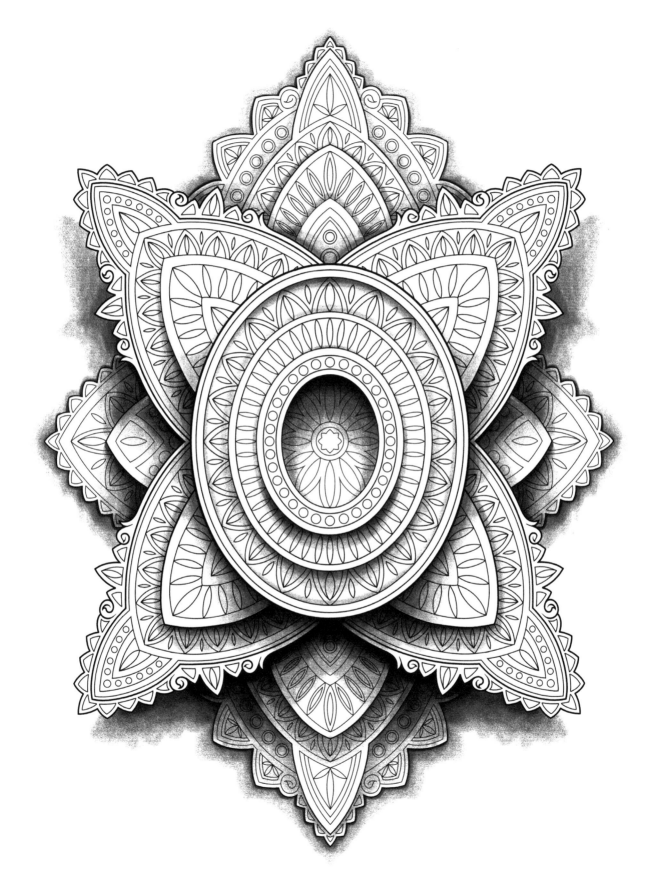

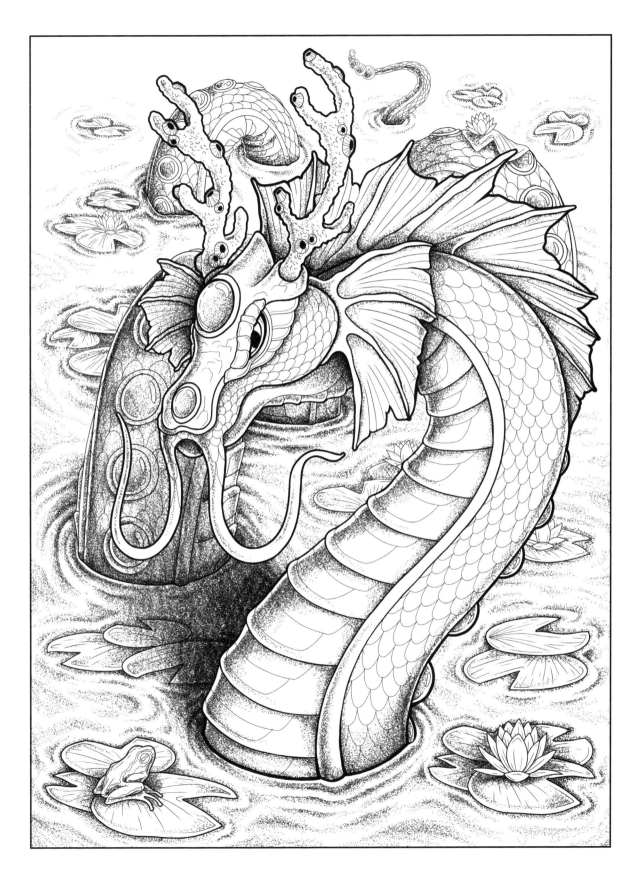

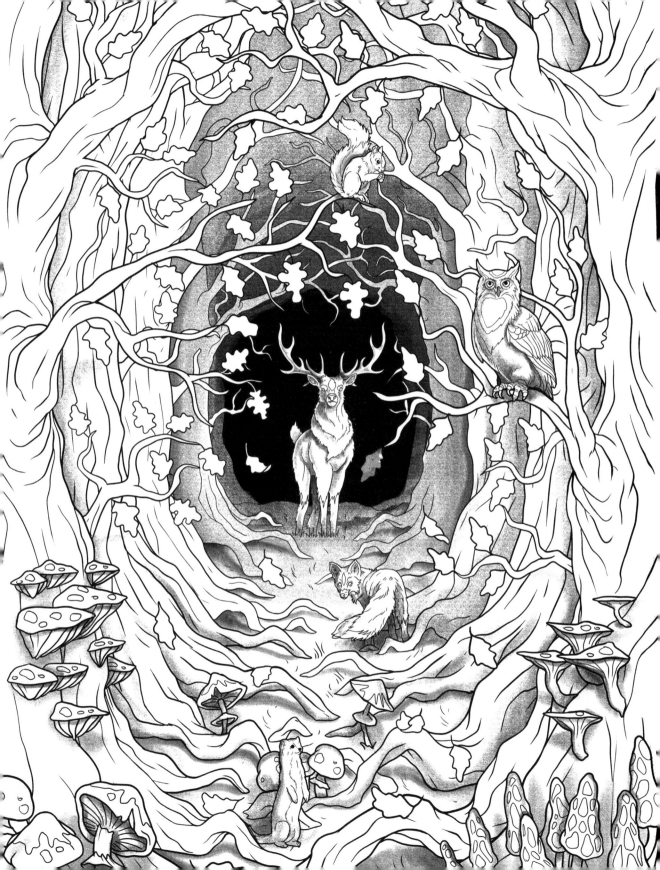

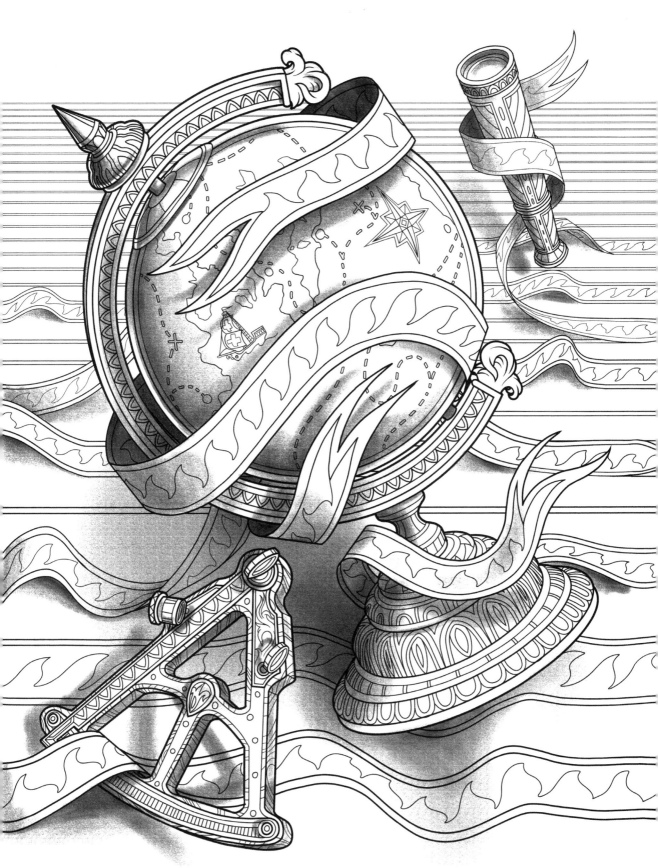

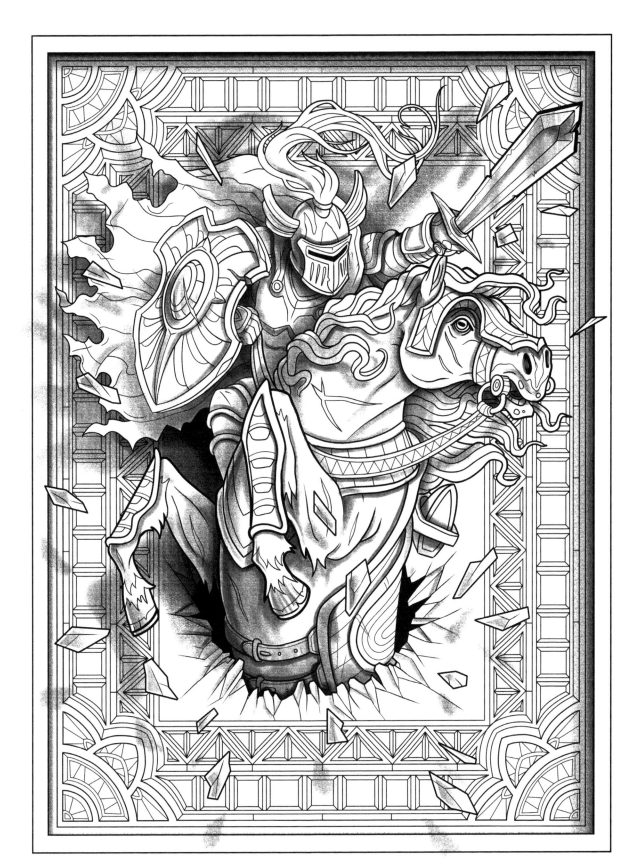

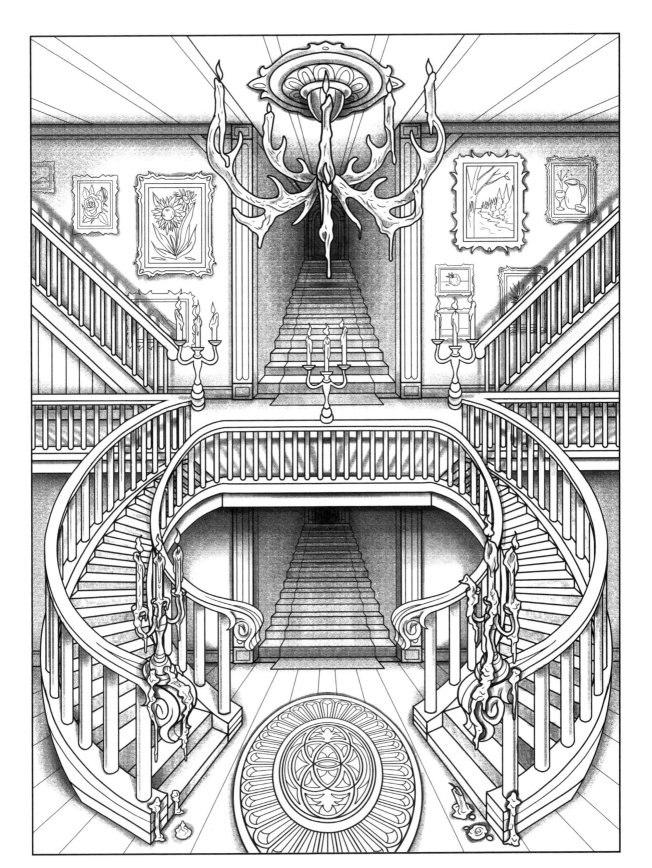

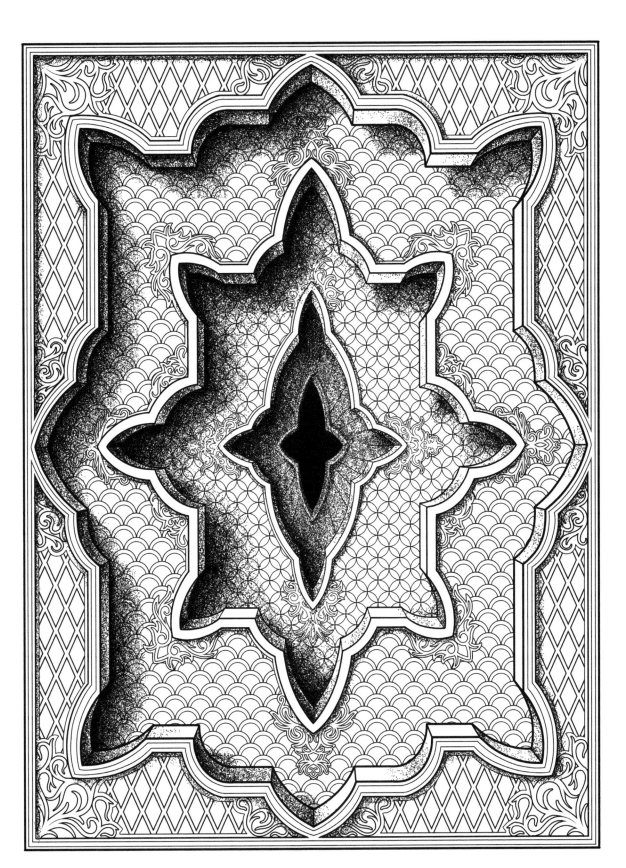

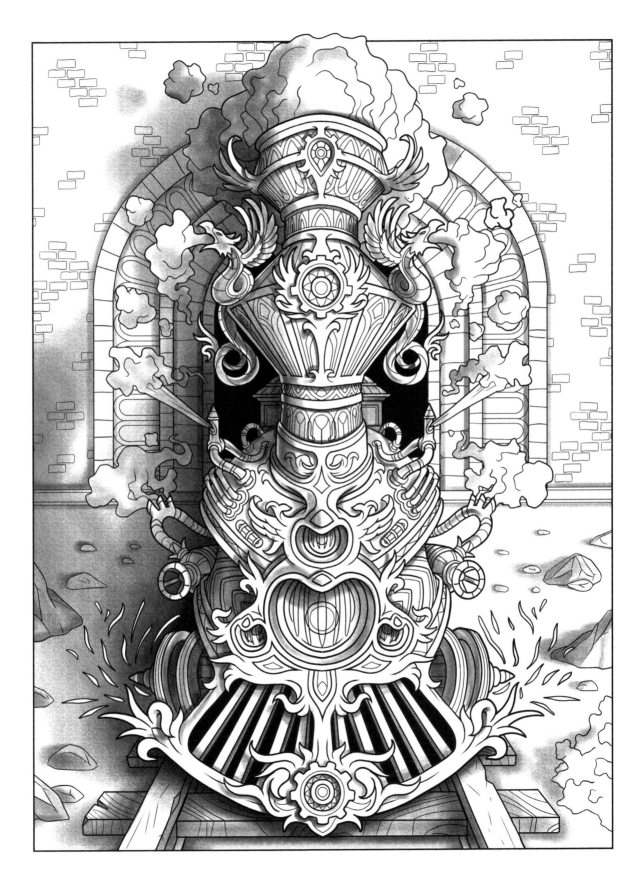

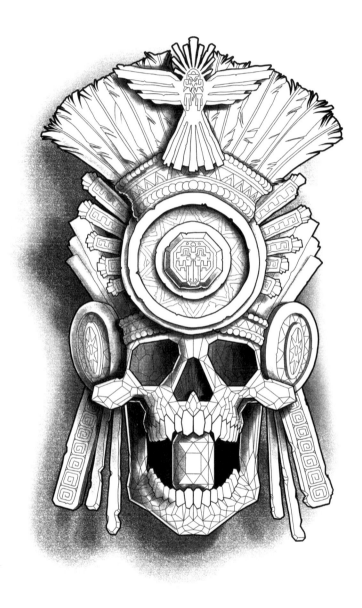